"I L♡VE TO READ"

Written By:
Amar L. Curtis
and
Felicia "Fe Fea" White Curtis

"I Love to Read"

To order additional copies of this book, contact:
Xlibris
844-714-8691
www.Xlibris.com
Orders@Xlibris.com

ISBN: 978-1-6698-6428-8 (sc)
ISBN: 978-1-6698-6429-5 (hc)
ISBN: 978-1-6698-6435-6 (e)

Print information available on the last page

Rev. date: 01/24/2023

This book is dedicated to every little black boy who loves to read, who wants to learn to love to read, and who is learning to read.

We see you! We hear you! We acknowledge you!

I love to read.

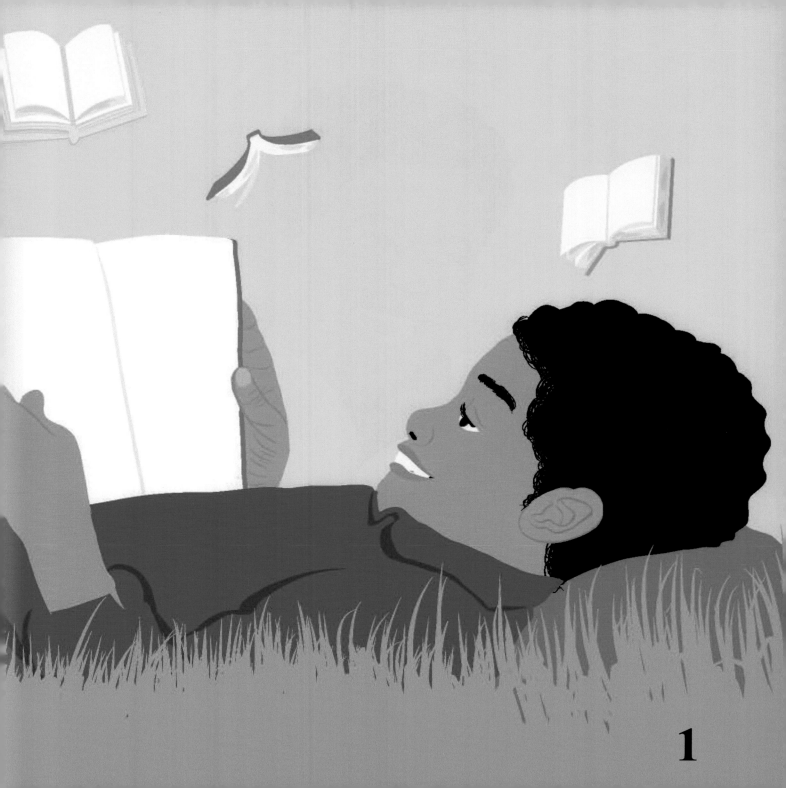

1

I love to read with my mom.

I love to read
with my dad.

5

I love to read
when I am happy.

7

I love to read
when I am sad.

9

I love to read in the morning.

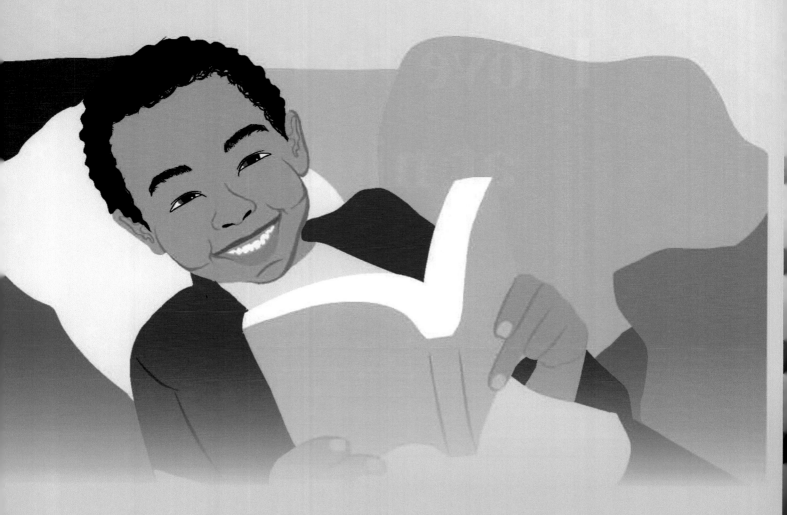

I love to read at night.

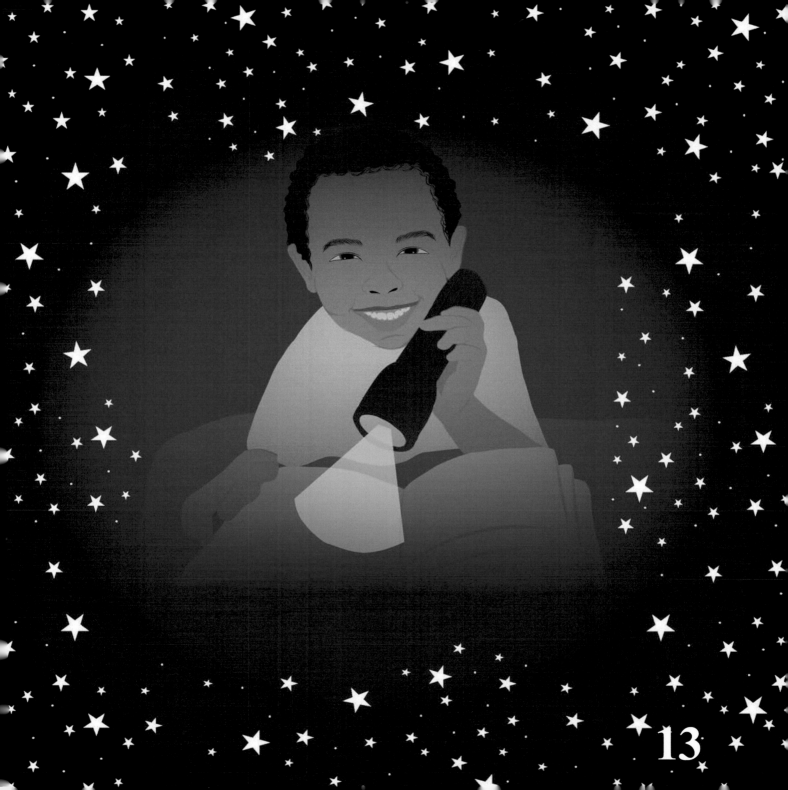

13

I love to read.

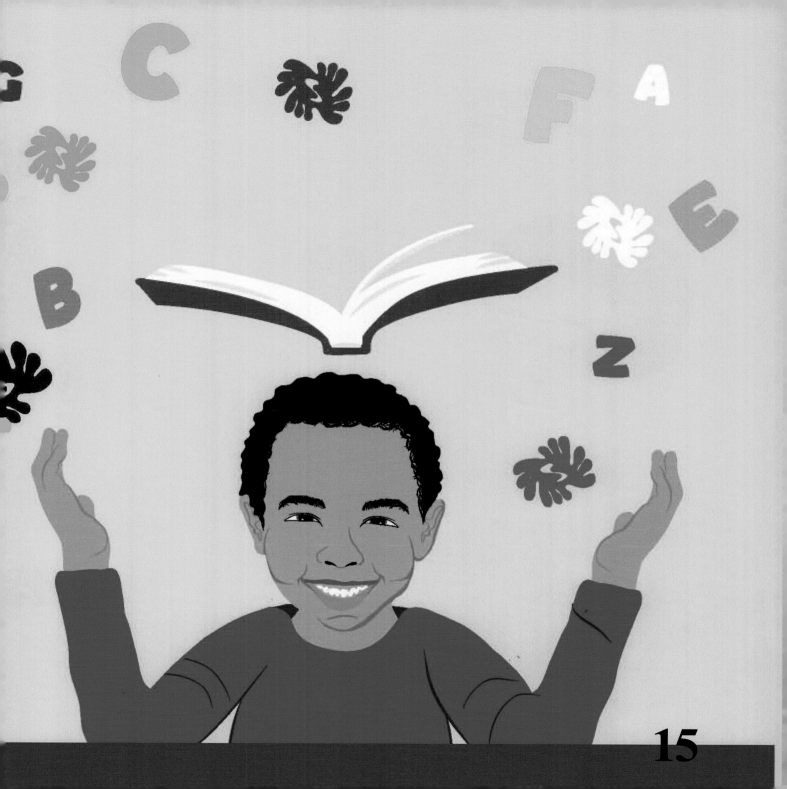

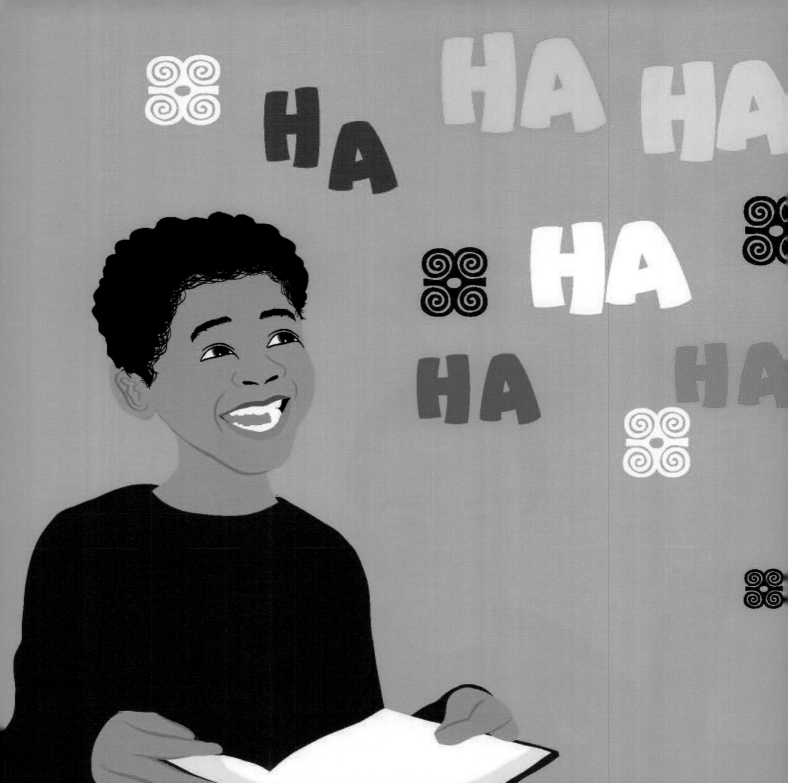

I love to read funny stories.

I love to read about sports.

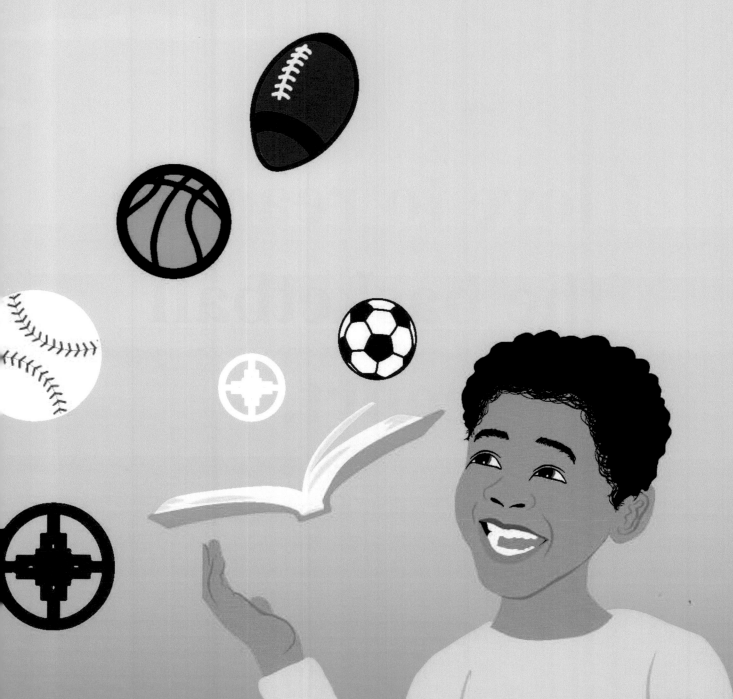

19

I love to read on the basketball court.

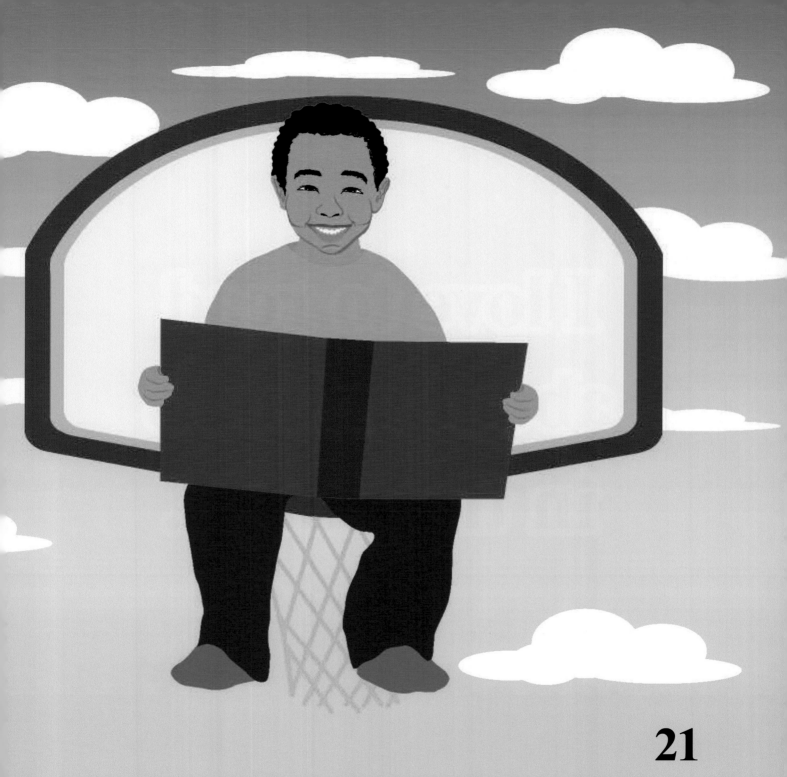

21

I love to read about animals in the jungle.

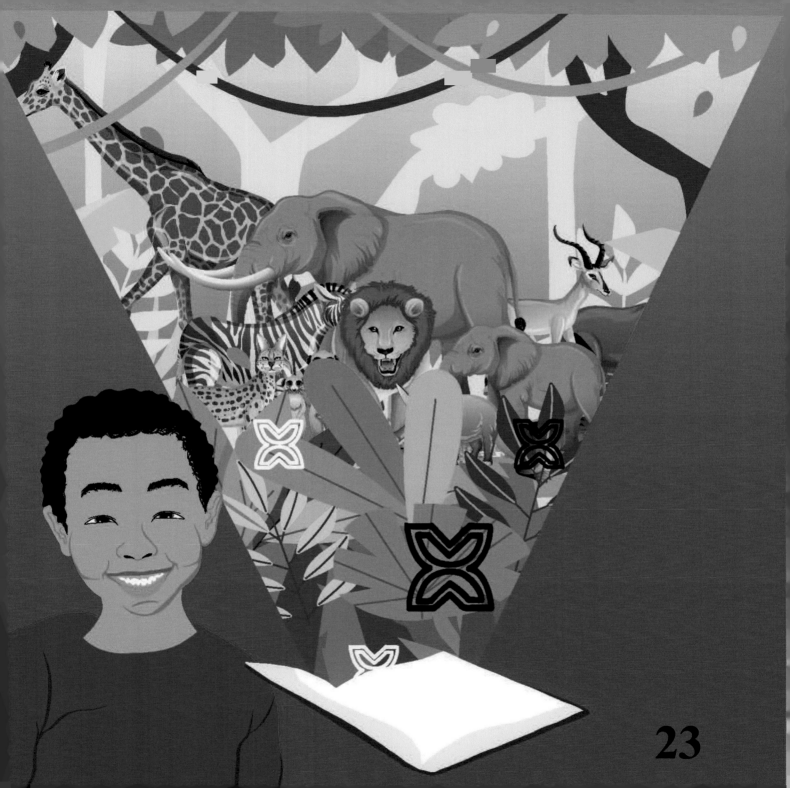

I love to read my books when I snuggle.

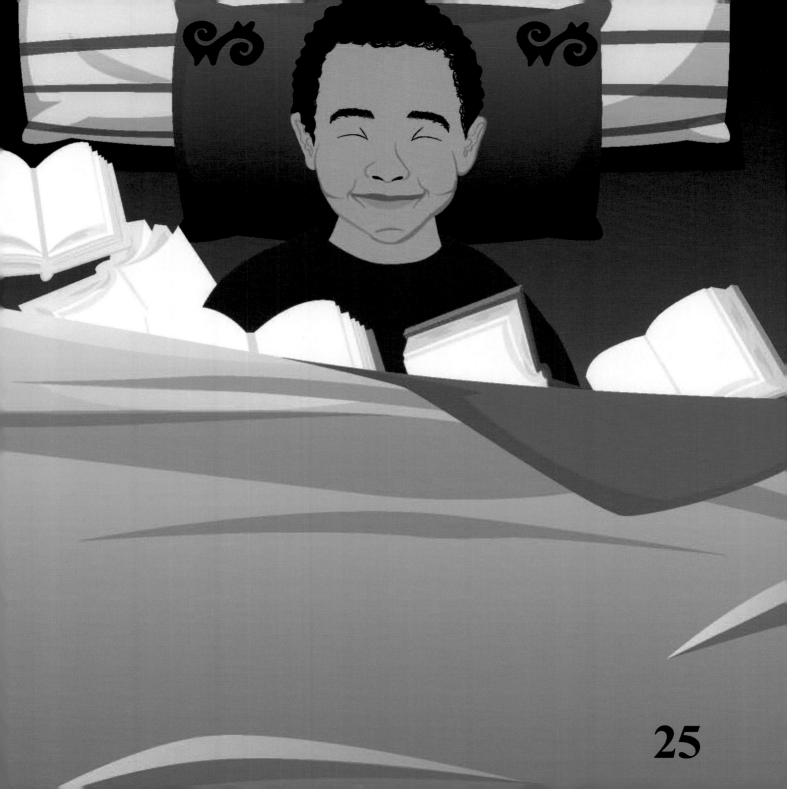

25

I love to read
with a friend.

I love to read my books to the end.

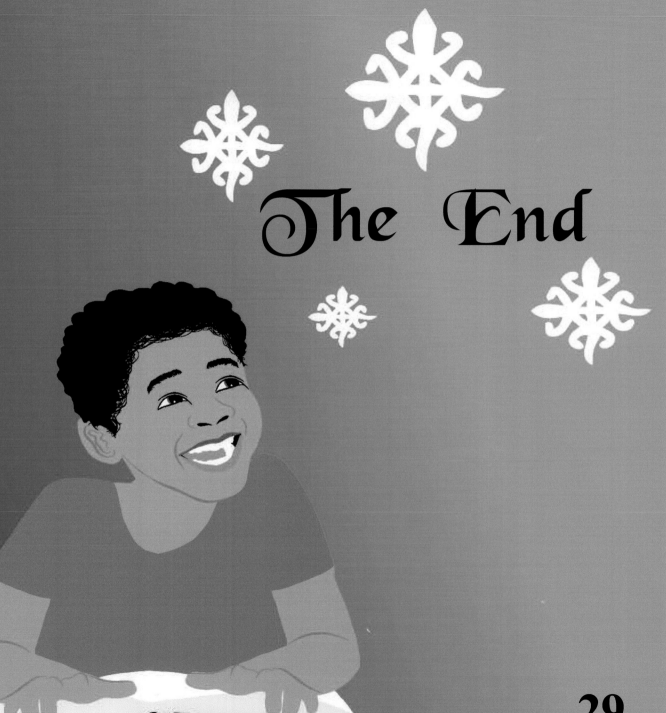

The End

29

I love to read.

Printed in the United States
by Baker & Taylor Publisher Services